HOW TO DRAW
ALIENS, MUTANTS & MYSTERIOUS CREATURES
CHRISTOPHER HART

WATSON-GUPTILL
PUBLICATIONS
NEW YORK

*For all of my readers—
you're the best!*

*For my daughters,
who are always willing to
take a peek over their dad's
shoulder and make comments.*

*For Maria,
for everything,
always.*

Senior Editor: Candace Raney
Project Editor: Alisa Palazzo
Designer: Bob Fillie, Graphiti Design, Inc.
Production Manager: Hector Campbell

Fonts used: Frutiger, Balloon, Bossa Nova

Contributing artists:
Bill Anderson: various inks
Derec Aucoin: 34–38, 41–43, 45–47, 50
Rich Faber: various inks
Tom Grindberg: 6–7, 25–27, 40, 54–59, 62–63
Christopher Hart: 2, 44, 48–49, 60–61
Andy Kuhn: 14–15, 20–21, 28–29, 32–33
Grant Miehm: cover, 7–13, 16–19, 22–24, 30–31, 39, 51–53

Copyright © 2001 Christopher Hart

First published in 2001 in New York by Watson-Guptill Publications
a division of BPI Communications, Inc.
770 Broadway
New York, NY 10003
www.watsonguptill.com

Library of Congress Cataloging-in-Publication Data
Hart, Christopher.
 How to draw aliens, mutants & mysterious creatures / Christopher Hart.
 p. cm.
 Includes index.
 ISBN 0-8230-1439-8
 1. Science fiction—Illustrations. 2. Life on other planets in art.
 3. Drawing—Technique. I. Title.
NC825.S34 H37 2001
743'.8—dc21 00-068581

Manufactured in China

1 2 3 4 5 6 7 8 / 08 07 06 05 04 03 02 01

CONTENTS

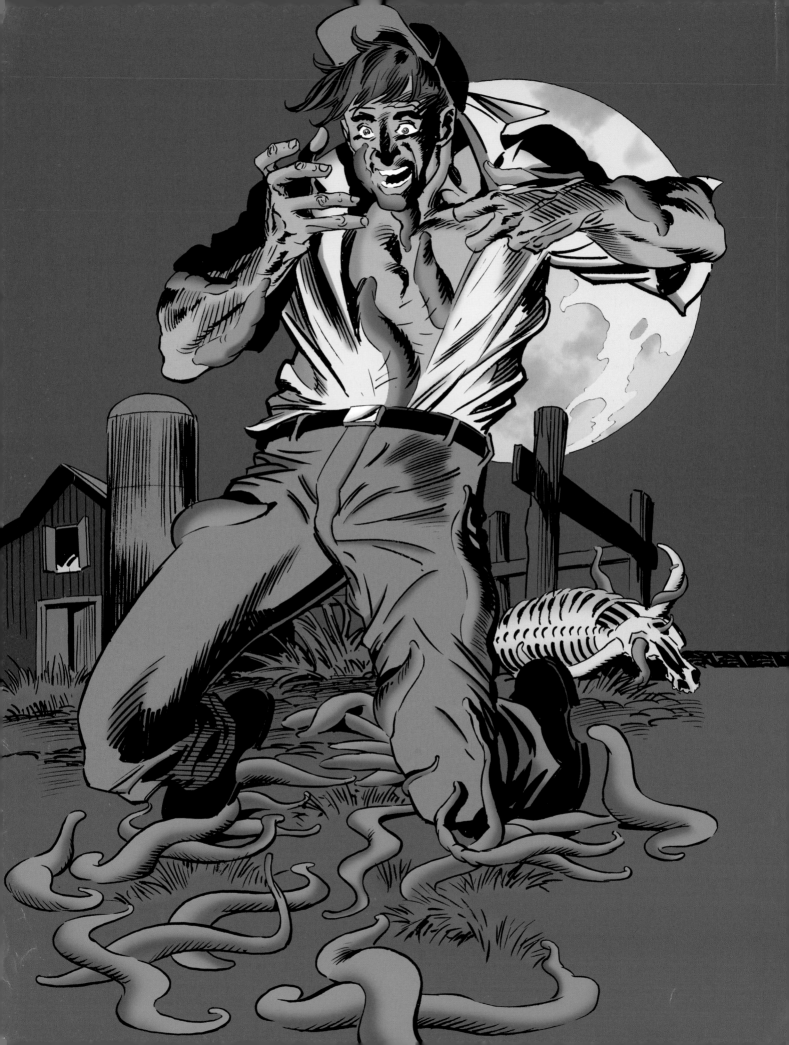

INTRODUCTION

I got really pumped when I thought of this book idea for you. Aliens have always been popular in sci-fi movies, but their popularity soared to new heights with the television show *The X-Files.* Then *The X-Men* movie came out and mutants, who were already huge—and the weirdest and most fascinating characters—in comic books and graphic novels, suddenly became blockbusters in movies, as well.

I grew up riveted to the adventures of the *Fantastic Four, The Incredible Hulk,* another mutant called Metamorpho, and probably some others too obscure to recall. The idea of a human being—or any life form—mutating into something else was eerily enthralling. What powers could they posses? Did their mutation warp their minds as well as their bodies? Did it make them smarter or, perhaps, even turn them into crazed geniuses?

Today, computer generated imaging (CGI) is evolving more and more, lending itself well to creating mutations, strange beings, and other special visual effects. And, the more computer technicians can do, the more they need artists to provide the basis—the *ideas*—for this wizardry. No matter what technical skills a person possesses, someone still has to come up with a great character first.

That's where *you* come in. In this book, you'll get the lowdown on how to develop and create your own cast of aliens, mutants, and mysterious beings. There are no rules for drawing these strange creatures, and don't let anybody tell you there are. It's not like drawing dogs, for which the anatomy of all breeds is basically the same. The creatures we'll be drawing come purely from the imagination and differ in appearance from anything on earth!

But although there are no rules, there are common themes and guidelines followed by most professional comic book artists that, when learned, will bring you much success in drawing your own captivating creatures. One such example is the altering of the number of digits. Since almost all the animals on earth who possess "fingers" and "toes" (or the remnants of them) have five of each, the first thing the pros do when drawing an alien or mutant is to give a creature two "fingers" instead of five. It's standard tricks like this that'll help you design your own weird characters.

And don't you worry—every type of alien being is in here, from childlike telepathic big-brained aliens to large-eyed amphibious creatures to alien soldiers. Likewise with the mutants: While you'll no doubt invent some new ones, all the well-established mutant character types are included—radioactive, hyper-smart, time-traveling, and more. You'll even learn how to draw alien and mutant eyes and how to show *what they see*—their field of vision *must* look different from our own.

And what about alien attacks and abductions? What, for example, do aliens do to their abductees? It's all here, along with complete information on drawing sensational robots and androids. Ask yourself, Do I know how to draw a fighting android? A butler robot? A remote-control helper cube? Keep reading and you will! You're going to get everything you need to know about drawing strange visitors from other planets. So grab a pencil, and join in the adventure.

THE NONHUMAN BASICS

Aliens and mutants may have started out pretty hokey as bit players in B movies but have grown tremendously in sophistication and popularity in recent years. They now command leading parts, playing tragic heroes and heroines endowed with amazing powers but at the same time cursed by their solitude.

1950s

1960s

1970s

Aliens and Mutants: Past, Present, Future

Aliens and mutants have had a long and distinguished career in movies and comics. Well, at least a long career, anyway. Truth is, these characters were pretty hokey, way back when. They looked like movie extras wearing one-size-fits-all Halloween costumes. But, when technology changed the nature of movie special effects, comic book artists seized the helm of this revolution and led the industry to never-before-dreamed-of heights. Overnight, aliens and mutants were transformed into hip, cutting-edge creatures. Let's take a forced march down memory lane to examine the mutants of yore—and be sure that we leave 'em there!

1980s & 1990s

PRESENT & BEYOND

Body Types

Here's something you'll never get in your average art course: a lesson on comparative anatomy between humans, mutants, and aliens. Mutants are humanoids—humans who have been altered but still retain some obvious human characteristics. Aliens, on the other hand, are not as closely based on the human form, because they've originated extraterrestrially (somewhere other than Earth).

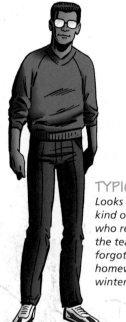

TYPICAL MAN
Looks like the kind of guy who reminds the teacher she forgot to give you homework over winter break.

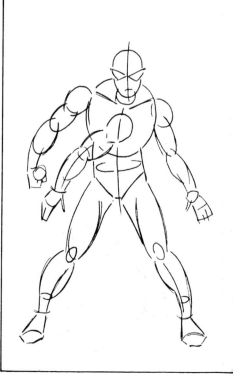

MALE MUTANT
This is what you get for playing with radioactive toxic waste. Next time, listen to your mother.

FEMALE MUTANT
Replacement parts are cool for mutants. (In Beverly Hills, many human women also get replacement parts, but that's a different story.)

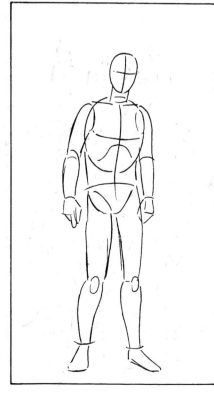

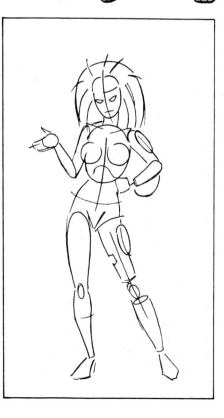

BRUTE ALIEN

This guy could be either alien or mutant. He retains enough human qualities in his arms, hands, and feet to be a mutant, but his face is decidedly alien. What he is depends on how the writer writes him.

LARGE ALIEN

Big aliens usually come with a significant "yuck" factor. This guy's skin looks like the stuff you wipe off the shower walls.

SMALL ALIEN

Nothing human here. Pretty much pure alien. His eyes don't even open. Looks like he could use a morning cup of joe.

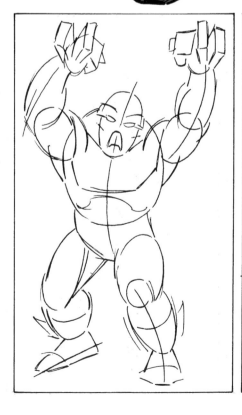

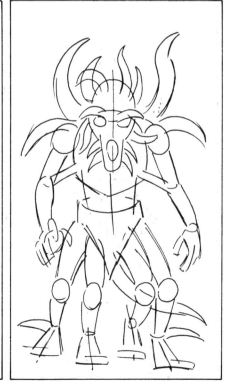

The Persistence of Form

Many earthly animals have five "fingers" and five "toes." Even if the digits have lost their function due to evolution, there are still usually five remnants in the animal's skeleton. For example, cats, dogs, and bears all have five skeletal "toes" buried in each of their paws. Most animals also have shoulder blades, a rib cage, a pelvis, and knee and elbow joints. These things persist from species to species, even in frogs.

This is good news for artists drawing aliens and mutants, and here's why: You can use the basic human form or skeleton, with which you're familiar, as the basis for your nonhuman characters. Once you have drawn the basic form, start tweaking it. It's much easier to change a human being into an alien or a mutant than it is to draw an entirely new species completely from scratch.

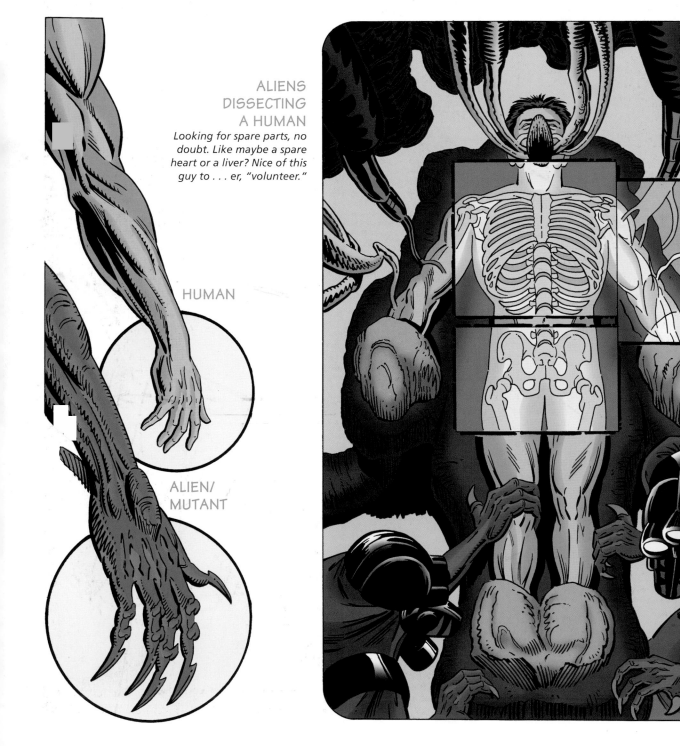

ALIENS
DISSECTING
A HUMAN
Looking for spare parts, no doubt. Like maybe a spare heart or a liver? Nice of this guy to . . . er, "volunteer."

HUMAN

ALIEN/
MUTANT

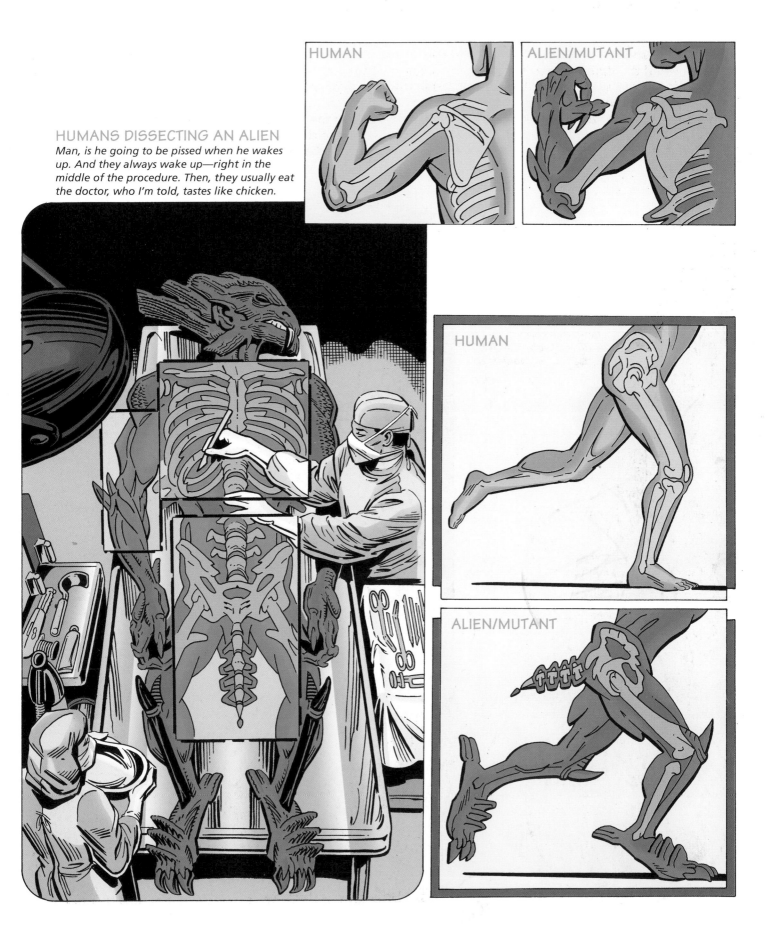

HUMANS DISSECTING AN ALIEN
Man, is he going to be pissed when he wakes up. And they always wake up—right in the middle of the procedure. Then, they usually eat the doctor, who I'm told, tastes like chicken.

HUMAN

ALIEN/MUTANT

HUMAN

ALIEN/MUTANT

11

The Hideous Transformation

The transformation process a human undergoes to become a mutant is usually chronicled at some point in the comic book story. This mutating occurs in stages, which makes for more dramatic storytelling. Often, these stages are painful and tortured. In classic Gothic movies, transformations also affect the mind. Therefore, the beginning of the transformation is terrifying, and the person tries, in vain, to resist. It's sort of like a single guy at the beginning of a relationship, before he gets married. Just kidding, honey.

But, midway through the transformation, the person's identity has changed enough that the transformation is actually welcome. Once a mutant, the character enjoys the superior strength and powers. Although it does make it harder to get a date.

Transformation Triggers

There are many triggers that can cause a transformation into a superhuman mutant. Usually, it's an accident or an experiment gone awry. The first choice usually involves the ever-popular radioactivity, but that's been done to death. Other accidents can involve spills in biohazard laboratories, toxic waste, genetic engineering, breeding with alien species, security leaks of super viruses, and contamination by alien spores or germs.

Some mutants return periodically to their human form, while others are changed forever. If the transformation was caused purposely, this implies that it was the result of an experiment, and that gives you a built-in villain—the scientist or professor who performed it. This also creates a strong "through line" (a strong thematic thread running through the entire story) for the mutant: to seek revenge on the professor who forever changed him (or her) into a monster.

Less Is More

Sometimes, you can make something look really weird by *leaving important details out.* These creatures are all missing something that we would normally expect to find on a human. And omitting that thing, whatever it is, makes these mutants look even creepier than they already are! Notice what the artist left out here: fingers, a nose, eyes, and hair.

Doing the opposite of the suggestion on the facing page is another effective technique for creating aliens and mutants. Consider doubling, or even tripling, the facial features, the number of heads, or the number of limbs.

Two Heads Are Better Than One

Nothing skeeves out a middle class, suburban family so much as being attacked by a marauding band of two-headed aliens or mutants. (Here's a helpful hint for your family's next road trip: Don't take shortcuts through graveyards. Just a suggestion.)

When drawing second heads, or second sets of limbs, be sure to choose which is the *primary* head and *primary* set of arms. The secondary head is an outgrowth of the primary head. The secondary set of arms isn't as securely attached to the shoulders as the primary set. If you were to remove the secondary arms and the second head, the creature would have a fairly normal anatomy. Clearly defining the primary appendages creates a more successful, dynamic character. For example, readers know which head to focus on when reading the character's expression. Readers also intuitively understand the body language, because they associate the primary arms with human arms.

Arms As Weapons

No wonder so many mutants turn to crime. You can't drive a cab with hands made of axes. How about the guy with the missile launchers for hands? What kind of job could he get? Not even a change-maker at an arcade. So they turn to crime. IT'S SOCIETY'S FAULT!

This arms-as-weapons technique makes for impressive evil mutants. They don't just carry deadly weapons—they *are* deadly weapons!

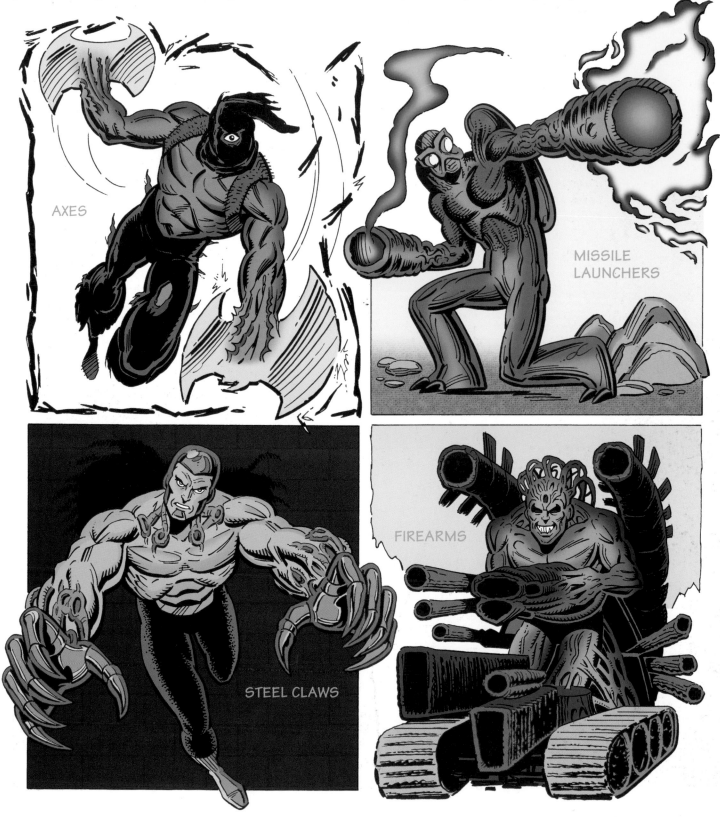

AXES

MISSILE LAUNCHERS

STEEL CLAWS

FIREARMS

Alien and Mutant Sight

Since alien (and mutant) eyes are quite different in shape and function from our own, what an alien sees will appear distorted to match its eye type. *Point of view* (POV) shots like the ones below show the reader the world as the alien sees it—through alien eyes.

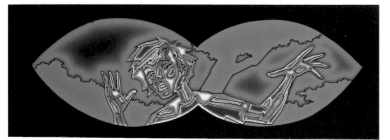

HEAT-SENSING POV
*Every living thing gives off heat.
If you're there, you're cooked.*

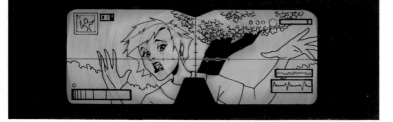

ENHANCED POV
*He'll zero in on you like radar. Better hope
he forgot to recharge his brain last night.*

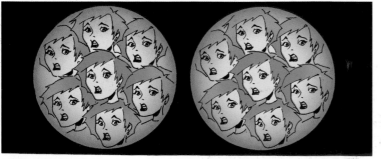

MULTIPLE POV
Yikes! Better spray.

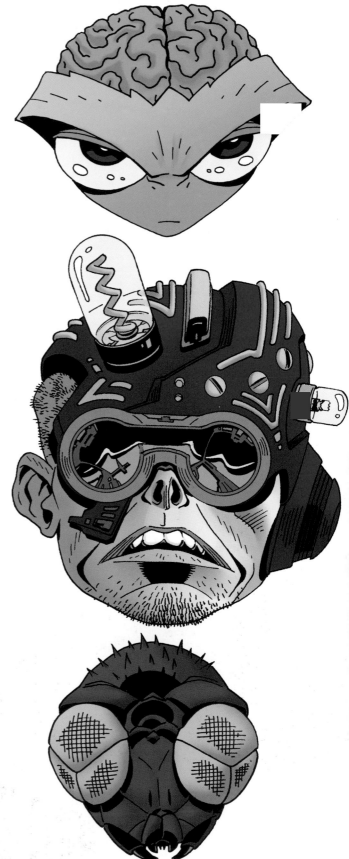

BLIND MUTANT

There have been many blind action heroes, aliens, and mutants. It's a popular device. The lack of vision makes these characters seem more human because they are vulnerable. They have inner struggles, navigating in a world of perpetual darkness. However, these characters are usually outfitted with motion sensors, which approximate vision (see detail)—only without the ability to see or appreciate beauty. Usually, blind mutants are outfitted with opaque goggles that shield their eyes.

Where Aliens Attack

In suspenseful comic books, secluded, dangerous, isolated places get the reader's anxiety going before anything actually happens. This lets you "milk the moment," stretching out the scenes in which you have your readers glued to the page. As a result, the reader will remember being on pins and needles through much of the comic book, which is a good thing. And this generates good word of mouth, which sells copies. So, here are some common alien attack locations (they're good for mutants, too):

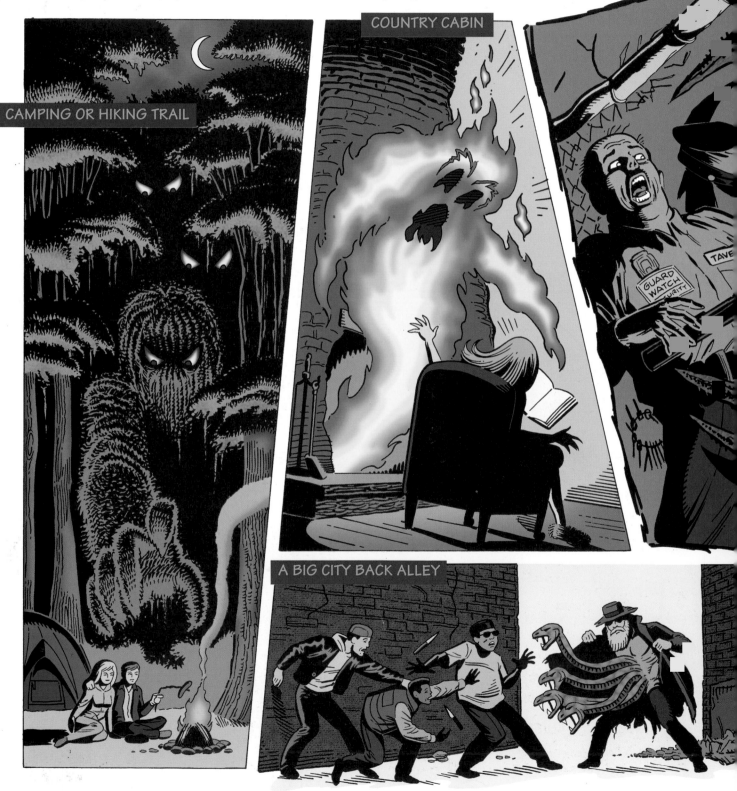

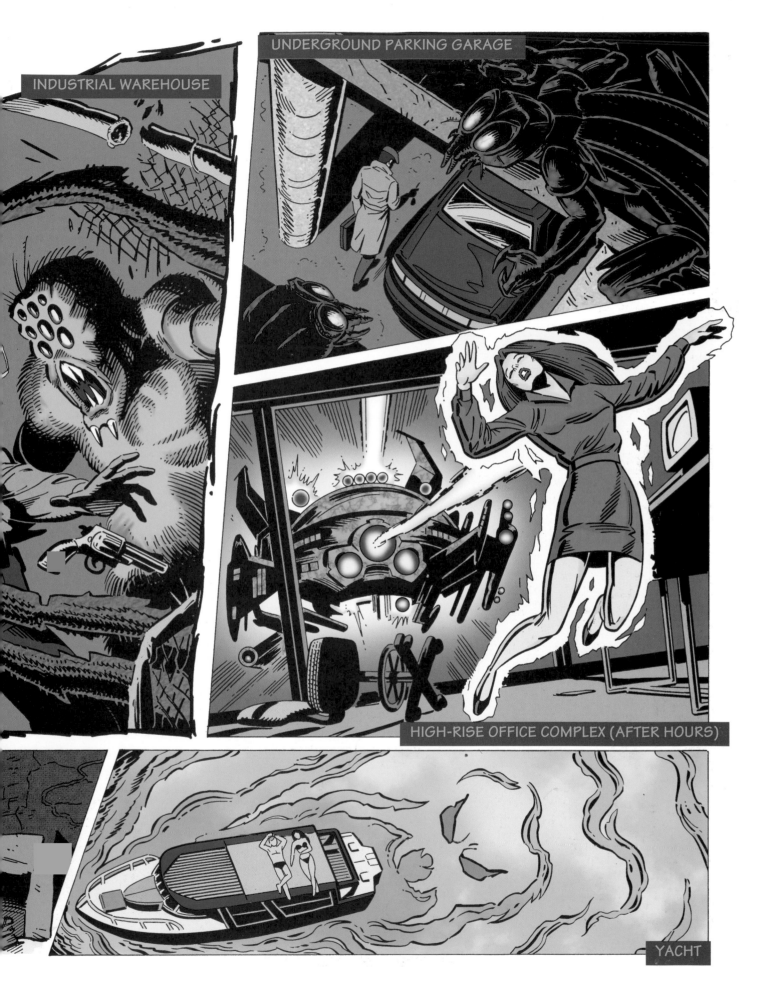

ALIENS

U ntil recently, almost all sci-fi that involved space aliens depicted them as hell-bent on invasion and Earthly domination. Steven Spielberg's *E.T. The Extra-Terrestrial* ushered in the warm and fuzzy alien lizard, but luckily, we're now back to shooting invaders out of the sky, which is much more fun than trying to teach each other songs.

Your Basic Extraterrestrial

Unless you've been hiding under a rock somewhere, you just know those bullets are going to bounce right off that alien. Artists usually give aliens big heads. We subconsciously feel that any creature able to fly here from outer space must be very intelligent and, therefore, have a bigger brain. Aliens also have a different number of fingers and toes. Since most creatures on earth have five digits (or the remnants of them), giving these aliens two fingers and a claw, along with two toes, indicates that these guys aren't from these parts. Notice the protective force field emitted by the alien. Without this, he would be totally defenseless.

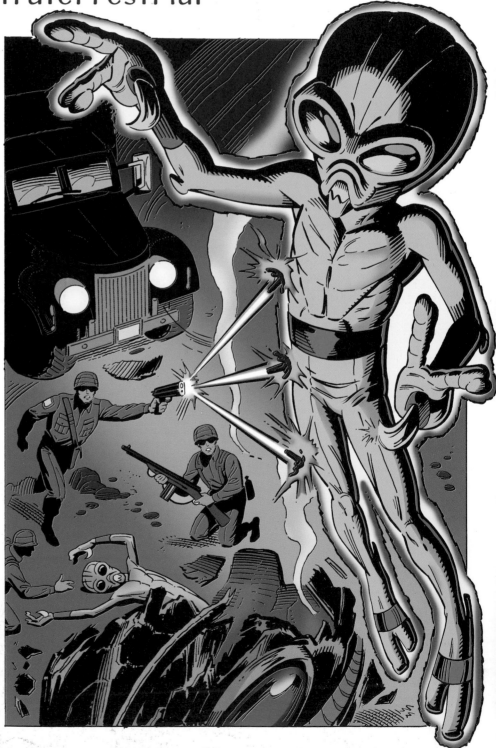

Hey Wilbur, Get the Camera!

Here they are: Aliens! Flying saucers! Green people! You and I both know that the only place these guys ever land is somewhere out in the boonies. Lucky break for them. If they landed in Brooklyn, they'd get mugged and have to fly back home empty-handed. These saucers are the typical 1950s type. No air, no sunroof. But they keep getting reinvented, sort of modernism-goes-kitsch. Sometimes it's cool to mine the past, as long as you put a new spin on it. The probe with the big eye in it is a new idea. It's going to greet the Earthlings. And then, it's going to obliterate them.

Holographic Images

Hey, these aliens are no dummies. You don't fly millions of light years and then just walk outside to greet guys with guns. Instead, you stay safe in your flying saucer and project an *image* of yourself to size up the situation.

The holograph should be translucent; this means that light can shine through it, but the conventional meaning for comic book artists is that you can partially see through it. The holographic image should be of the alien leader. It should be big. And it should tower over any Earthlings. The holograph should make the army guys look like little kids with toy guns.

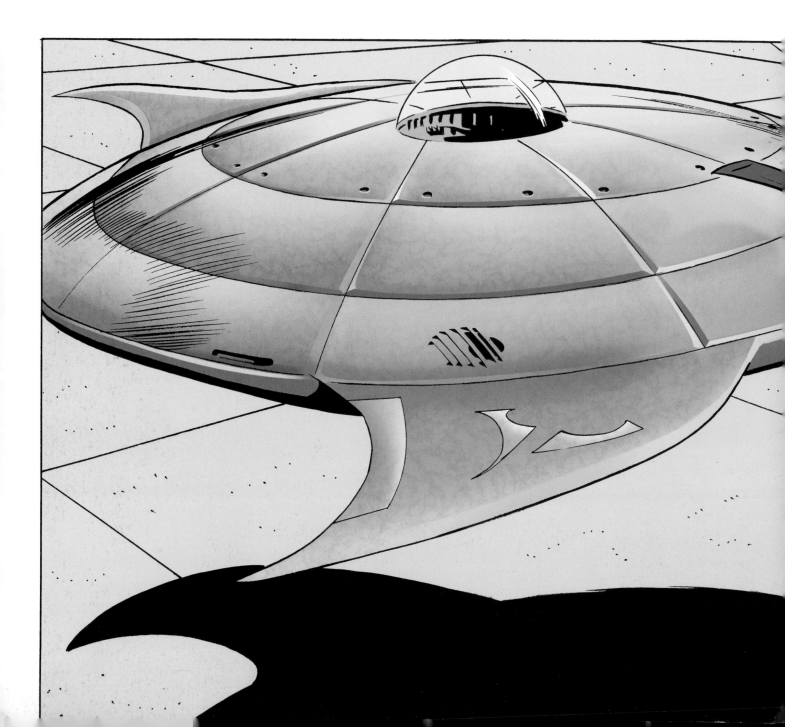

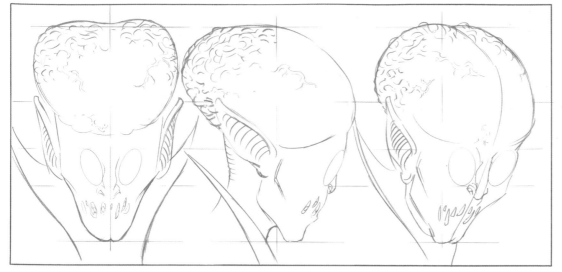

ROTATING IMAGE

It's an effective device, especially in animation, to show an alien's holographic image in a continuous state of rotation, as if the aliens were using the image as a tool to survey the landscape 360 degrees. In order to rotate the head, you've got to be able to draw it from all important angles. Each angle emphasizes a different facet of the face. For example, here the front view emphasizes the front of the brain and the eyes. The side view emphasizes the large mass at the rear of the brain, as well as the ear. The 3/4 view emphasizes the far cheekbone and the harsh angularity of the face.

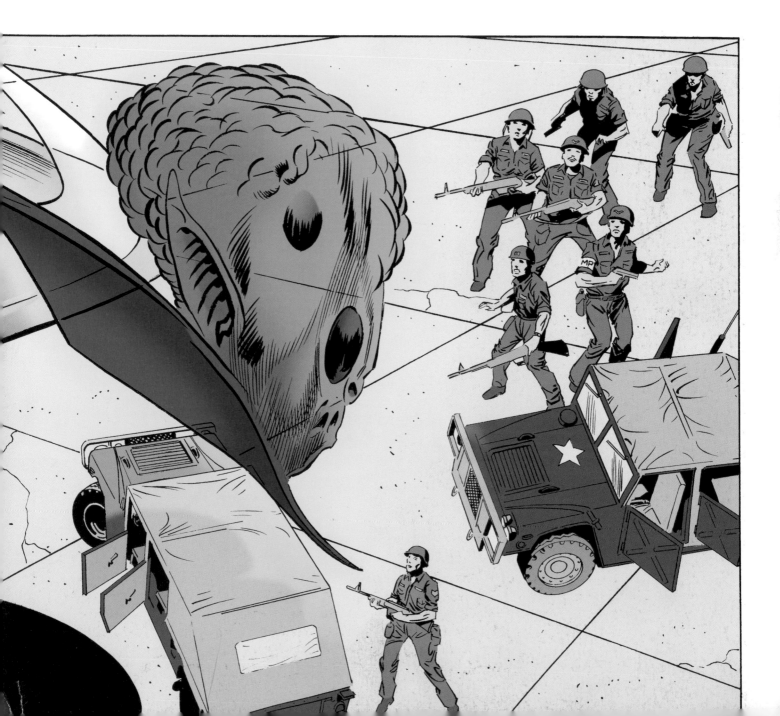

Methods of Alien Attack

Here are a few of the most popular ways that aliens attack, gleaned from the alien playbook. Try to invent some of your own. It might lead to a great new character in a new comic book.

ENTRAP IN A FORCE FIELD

LIQUIFY

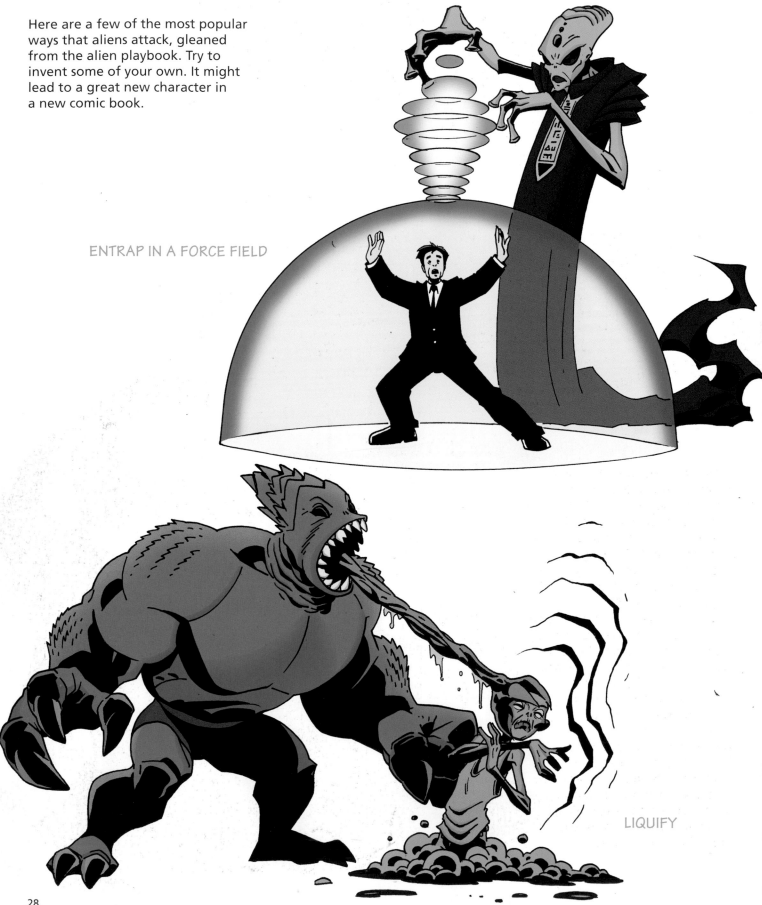

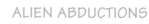

IMMOBILIZE
WITH STICKY
SECRETIONS

ALIEN ABDUCTIONS

There are many people who claim to have been abducted. I believe these people. Why would they lie? Just because they lead small, meaningless lives in some Podunk town and would kill to get their fifteen minutes of fame, you think they would make all of this up? Boy, are you cynical!

Anyway, aliens are reported to abduct people and perform grisly experiments on them. Sometimes the aliens implant secret devices in them. Sometimes I wonder if they're just doing a root canal. Be that as it may, the aliens usually return the people to earth, where they walk around dazed and mumbling about being captured by strange beings. Of course, no one believes them, which, as Oliver Stone might assert, is proof it's a conspiracy.

All alien operations are performed on a gurney that uses heavy restraints.

29

Telepathic Communication

Aliens communicate in a manner that's way, way beyond cell phones. They communicate directly from one mind to another. Here, the aliens line up to receive their instructions from their evil alien leader. Even though these aliens look like children, they're really hundreds of years old. Their bodies have grown almost useless as their powers of mental telepathy have increased.

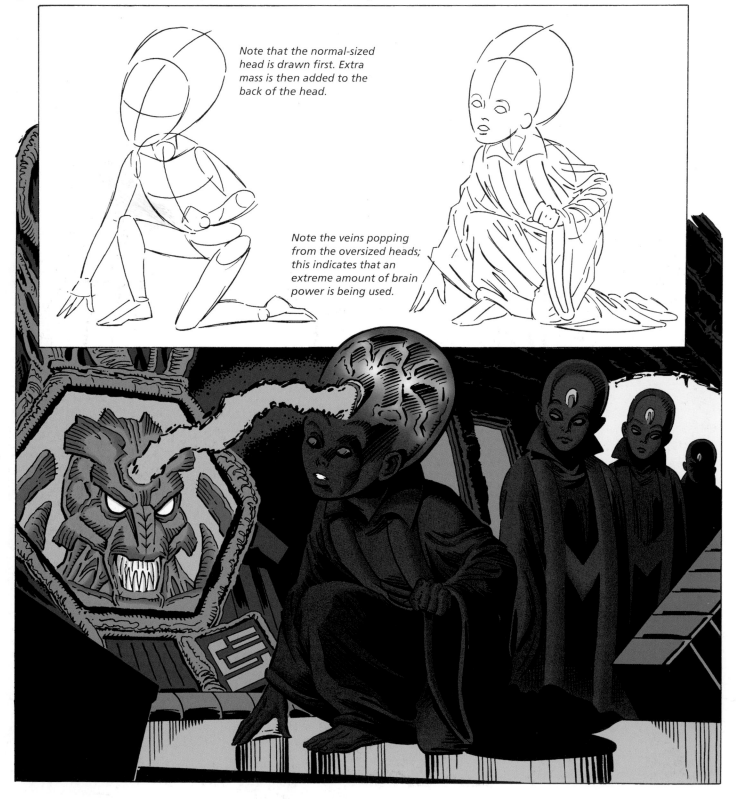

Note that the normal-sized head is drawn first. Extra mass is then added to the back of the head.

Note the veins popping from the oversized heads; this indicates that an extreme amount of brain power is being used.

When Aliens Take Over the Earth

These are the more primitive types of aliens—the Neanderthals of outer space, if you will. They're rounding up the humans and deporting them to special "re-education camps" where their minds will be "cleansed." Aliens like these should wear military-type outfits because they're soldiers, very visibly posted at all major city landmarks.

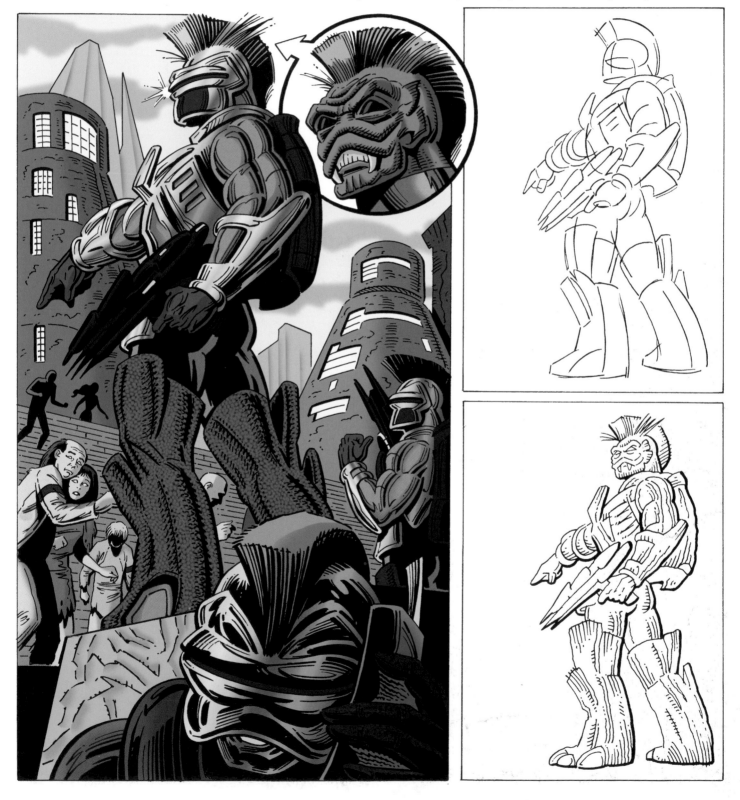

From Insects to Aliens

It's going to take more than the exterminator to get rid of these pests. Insects have provided a basis for sci-fi and comic book characters for as long as the genres have been around. They are great for inspiration because they're alien looking and repulsive. Every baby animal in the entire world is cute, except insect babies. Ever see a cute larva? I rest my case. By making a few changes to the basic designs of insects and standing them upright like humans, you can devise the creepiest of creepy aliens.

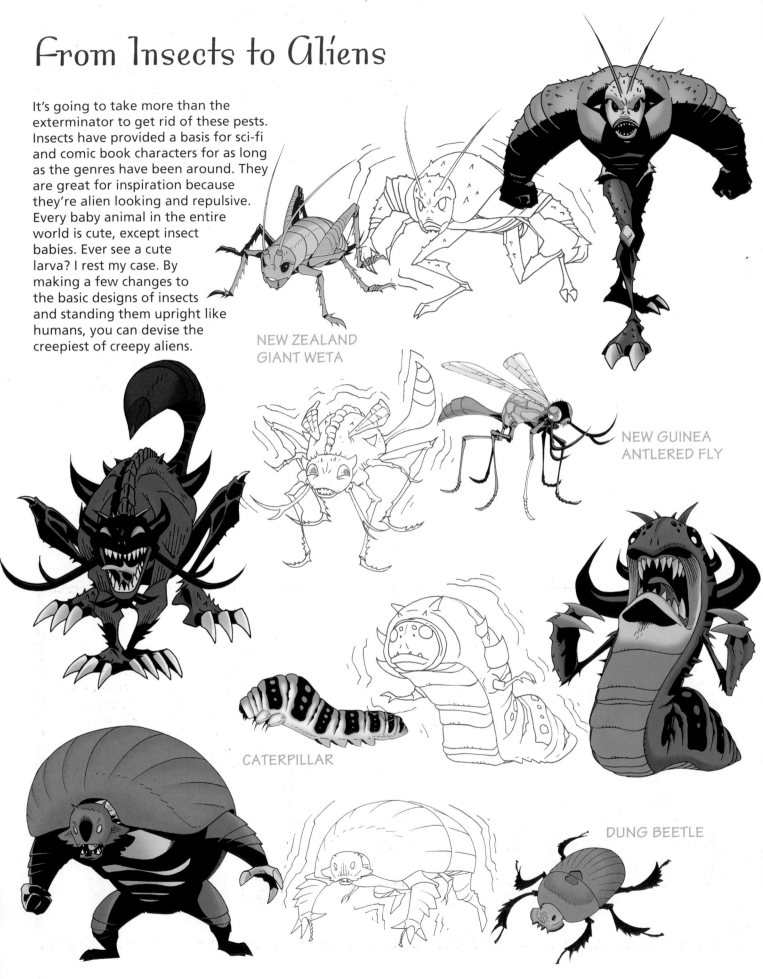

NEW ZEALAND GIANT WETA

NEW GUINEA ANTLERED FLY

CATERPILLAR

DUNG BEETLE

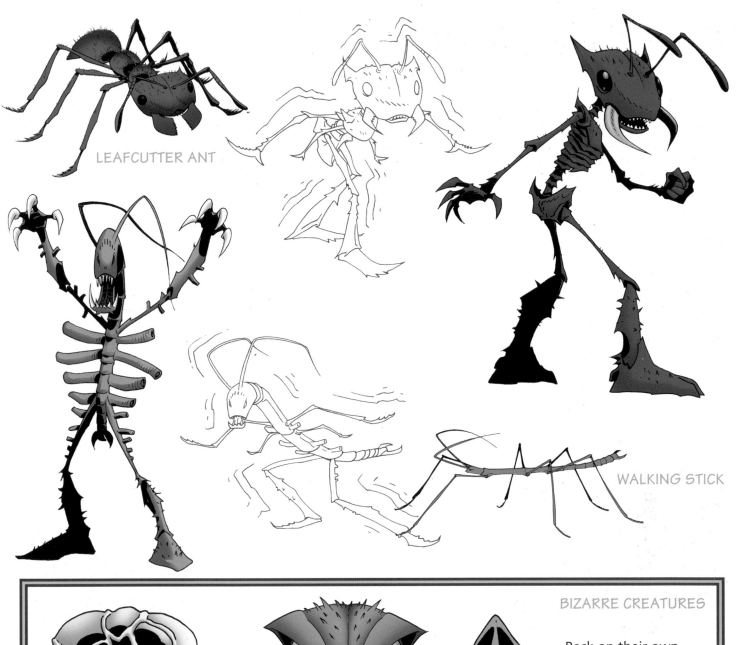

LEAFCUTTER ANT

WALKING STICK

BIZARRE CREATURES

Back on their own planets, each of these "chicks" would be a "ten." To each his own. I prefer my women without antennae or brain veins, but then, why should looks be so important? It's what's *inside* that counts. These specimens have been loosely borrowed from an octopus, ant, anteater, and grasshopper.

MUTANTS

Here we go, comics fans, right into the heart of the strange and the weird. The mutants are coming. Duck!

Using Human Anatomy

This character is a good example of how you can exaggerate normal human anatomical features, such as the vertebrae of the spine, to the point where they become the hallmark of a mutant. Of course, those neat, talonlike toes help, too.

The artist sketches out the entire figure first, before indicating the prominent mutant features. This is because the pose is more important than the special effect. Most beginning artists spend way too much time on the weird features and not nearly enough time on constructing a good pose.

Note the sweep of the spine, which curves gracefully around the entire back. This "line of the spine" then becomes a platform on which to build the protruding vertebrae.

Some Special Talents

MULTIDIMENSIONALITY

Caught between the shifting sands of space and time, this mutant exists in the present and the future simultaneously. He appears as a time traveler to warn the people in the present about their destiny in the future. However, in the ultimate paradox, if he succeeds in changing their course, he will create a world in which he never existed, and therefore, he will enter oblivion.

Notice that all the sharp daggers piecing his body make for good weapons; he's not just pierced, he's armed to the teeth!

SELF-MUTILATION

Some people just don't know what to do with all their nervous energy. This self-mutilating mutant is in desperate need of a wholesome hobby. He has such an evil, warped mind that he has turned his body into a reflection of his inner turmoil.

This kind of mutant loves pain—inflicting it and receiving it. This trait makes for interesting fight scenes. Imagine hitting this guy with your best punch. How's it gonna hurt him? Do you think this guy *minds* pain?

Mr. Drippy

Comics are famous for guys who are half this and half that. In this case, he's half normal and half melted ice cream. Maybe you're asking yourself, Why is he scarier than a normal guy? If anything, shouldn't he be *weaker* than an unmelted guy?

Whether you asked yourself these questions or not, I'm going to answer them. Basically, we're all afraid of things that are disturbing to look at. And when you're drawing mutants, the more disturbing, the better. The fact that his looks are as vile as they are gives him power over us. In addition, he seems to actually *enjoy* his condition, which means he's feeding off of it. More likely, he's getting his strength from that plutonium. (Maybe he could cut down by going on a plutonium patch. It's a thought.)

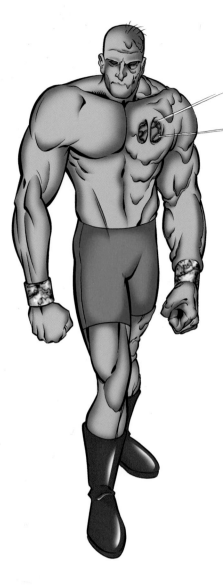

Don't indicate most of the drips of goo in the initial sketch, when you're still forming the pose.

NEVER PUNCH A GUY MADE OF GOO

It's hard to beat up somebody when they're the consistency of key lime yogurt. The secret to drawing goopy guys is that they can control, to some degree, their own texture. For example, that right cross that Mr. Gooey is about to land on the normal guy is going to be plenty hard when it makes contact.

Extreme Squishiness

I told you not to get him mad. Now see what you've gone and done?! This is about as disgustingly, gelatinously, oozy as you can get before the character completely degenerates into a mud pie. These mutants attack by smothering their opponents, who stick to their slime like flies to fly paper.

Mutant Babes

How do you create a babe who's a mutant but still retains her sex appeal? Obviously, you can't put horns growing out of her face and eyeballs dangling from her ears. So, one trick is to change the texture of her skin rather than create structural or skeletal changes—although minor additions, such as a tail or wings, are fine.

RADIOACTIVE

CALCIFIED

METALLIC

REPTILIAN

Mermutant

Mutants evolve in the sea, just as they do on land. The aqua-babe mutant is always sexy due to her skimpy attire and her wild look. Much like ordinary mermaids, she's shrouded in mystery since she can always disappear back into the deep. *She* decides when and to whom she will reveal herself. She's an extremely strong swimmer, which should show in her athletic shape. Although she's well muscled, she's always feminine looking. Make her look extremely fit but not like a bodybuilder. It always improves aqua-babe scenes to show the waves crashing about her.

Skin Problem?
What Skin Problem?

Come on, let's be realistic. You can't hang out in a radioactive toxic waste site and expect nothing to happen. These types of finned, semi-amphibious creatures have been around for a long time because they're very reliable characters. If you need something to rise up from the muck, call on this type of mutant. Need something to terrorize an isolated, broken down nuclear facility or hide in riverbeds? He's your guy. Scales, fins, webbing, and warts are all essentials for this dermatologically challenged being.

Turbo Brain

Diabolical, demented scientists aren't necessarily concerned with attaining superpowers. They have lots of brutes to do their strong-arm work for them. No, what they need is super intelligence. The type of intelligence that can crack the world financial community's computer code. The intelligence that can figure out a way to break into any nuclear bomb-making facility or engineer deadly germs and viruses of mass destruction. And to do that, an evil scientist needs more brain power. Super brain power. Sure, he could get a volunteer, but then if the experiment worked, the volunteer would have all the power. Better to perform the experiment on himself!

The exposed brain is a bit disturbing, and that's good because it immediately grabs the reader's attention. When you look at this guy, you're not first looking at his costume or electronic backpack but at that brain.

ROBOTS AND ANDROIDS

I happen to be a big fan of the android genre. These slick, soulless creatures make terrific antagonists because they can't be talked out of their wicked ways—they're just following their programming.

Robots vs. Humans

Many beginning artists believe they should draw robots using only straight lines and sharp angles, like a box. However, robots are weirder looking and more haunting if drawn to resemble human anatomy, with its curved shapes.

EXTEND

CONTRACT

CONTRACT

EXTEND

Notice the hydraulic pumps that govern the motion of the robot arm. These pumps extend and contract, just as the human arm bends and straightens.

The Incredible Will to Survive

Robots are rarely down for the count. They're programmed to continue their mission no matter what. They're the pit bull terriers of the comic book world and don't know the meaning of the words "give up," which is what makes them such great characters. This unfortunate robot has been blown to bits. Readers assume, as does the hero, that the fight is over. A beat later, we see that the robot is actually reassembling itself and will be as good as new in minutes!

Borrowing from Animals

You don't have to draw a specific species of animal as a robot in order to use the animal form. You can instead *borrow* the general posture, heaviness, gait, and intention of the animal and use those things as a foundation for your character. This robot isn't literally a bear, but it will somehow register as one with the reader on a subconscious level. You can add all sorts of things to the robot to counter the image of the bear, including that horn, shaped like a drill, on the forehead and the tail that looks like something from a dinosaur.

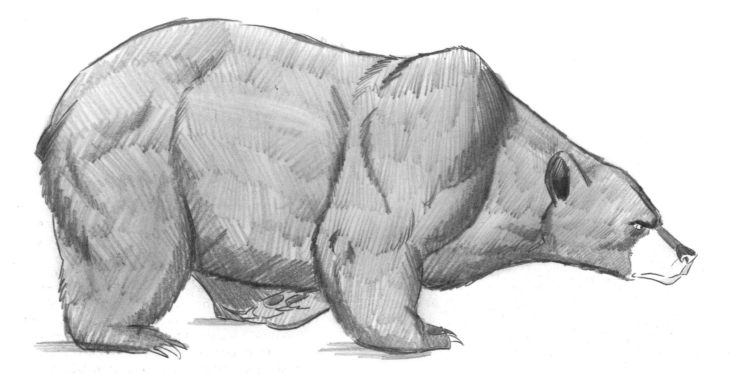

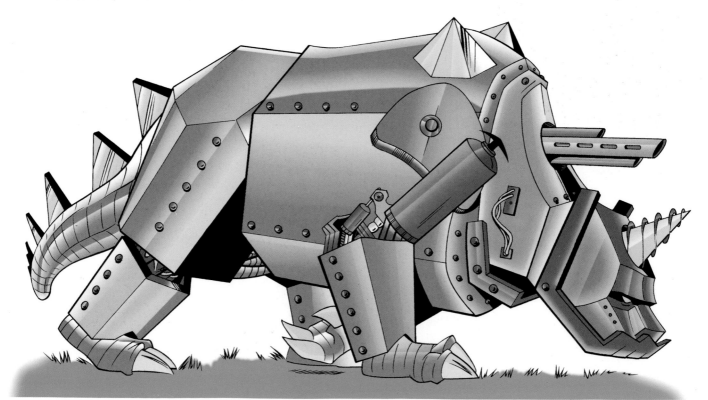

Do Not—I Repeat—Do Not Feed the Bird!

Folks who are afraid of birds in general are going to have a serious problem with these things. In case you haven't guessed, they don't eat bird seed. Robotic birds are not the feathery creatures with which you and I are familiar. They're more reminiscent of pterodactyls from a prehistoric era. This makes them primitive and terrifying. Make sure that the technobird has sizable talons, the sharp beak of a predator, and long spiny wings.

Beware of Robot

Here's your basic thief. He never learns, does he? It's enough to make a guy give up crime altogether. Anyway, robot animals are among the fiercest creatures on the comic book page. Although seeming to weigh a lot, due to its metallic composition, this frisky little fella can leap and grab onto the arm, head, or neck of any television "repairman." And the great thing about this dog is that it doesn't have accidents on the carpet! The worst you get is a little oil spill.

The Robot Dog Step by Step

In the morning, this dog makes *you* get *its* slippers. Be sure you get the anatomy correct when drawing the robot dog. The hind legs give many people some difficulty; they have three major sections. The first travels from the "hip" down to the "knee," the second travels from the "knee" back toward the tail, and the third travels from there straight down to the ground. Also note the wide stance, in which the front paws are far apart from each other, as are the hind ones. This gives the robot dog more of a fighting look. The closer together the feet, the more the animal will seem built for speed rather than for aggressiveness.

You Rang, Madam?

Good help is so hard to invent. No house of the future would be complete without a robot butler tending to your every whim. It never complains or asks for a raise or time off. It is the perfect little servant in that it doesn't even have to talk. Servant-type robots are designed differently from the powerful, fighting robots of comic books. While they must have the bulky qualities of a robot, they should have diminished stature in other ways. The robot shown here has bulky arms, but the joints between them are strikingly thin. The body is slender and doesn't have shoulders or a chest, both of which would add a feeling of power, which a servant shouldn't have. That tiny wheel it rides on is almost delicate.

Hold Still, This Will Sting

Sometimes, gang, the servants become the masters. To depersonalize this robot one step further, the artist gave it a camera instead of a head, which means, of course, that there can be no reasoning with it. It's a machine, programmed to perform an experiment on humans, and it will fulfill its objective. And in case you haven't guessed, that's not the cure for baldness that it's trying to discover.

Even though this "female" robot is obviously exceedingly strong, the pose still reads as feminine. What makes it so? Putting stress on the weight-bearing leg and pushing the hips out to one side. Let the upper body compensate by bending in the opposite direction of the hips—the hips tilt up to the right, the shoulders tilt down to the right. The overall curvy shape of the figure also helps create a feminine look: wide on top, tiny waist, wide hips.

Androids

An android is a super high-tech robot that looks like a human or, in some cases, an animal. Androids are extremely strong, and all of their five senses are far more acute than those of their human counterparts. They can live for thousands of years. They never grow old. They usually have a thin layer of living tissue covering their metallic form that gives them their human appearance. They can think but have specific instructions programmed into them. One might be to serve and never harm. But since androids are thinking beings, they sometimes find a way around these parameters, and that's when the fun begins.

When designing the working parts of androids, concentrate less on technical-looking doodads and gizmos. Instead, focus on hydraulic pumps and heavy metal casement and tubing. The idea is to make the androids appear strong, not high-tech. It's a given that they're high-tech. You want to convince the reader that they are functioning machines.

YOU PICKED ON THE WRONG GUY, FELLA

Part of the fun of androids is that you don't always know who they are. An android could look like an average schmo. The only way to know for sure is to peel back or accidentally rip the "skin" layer.

Domestic Help from Hell

She cooks gourmet meals, she cleans up all your messes, and she polishes everything to a gleaming shine. But, she can also lift the piano over her head, so don't get on her bad side. It's important to make all of her amazing feats of strength seem effortless and to give her a plastic smile.

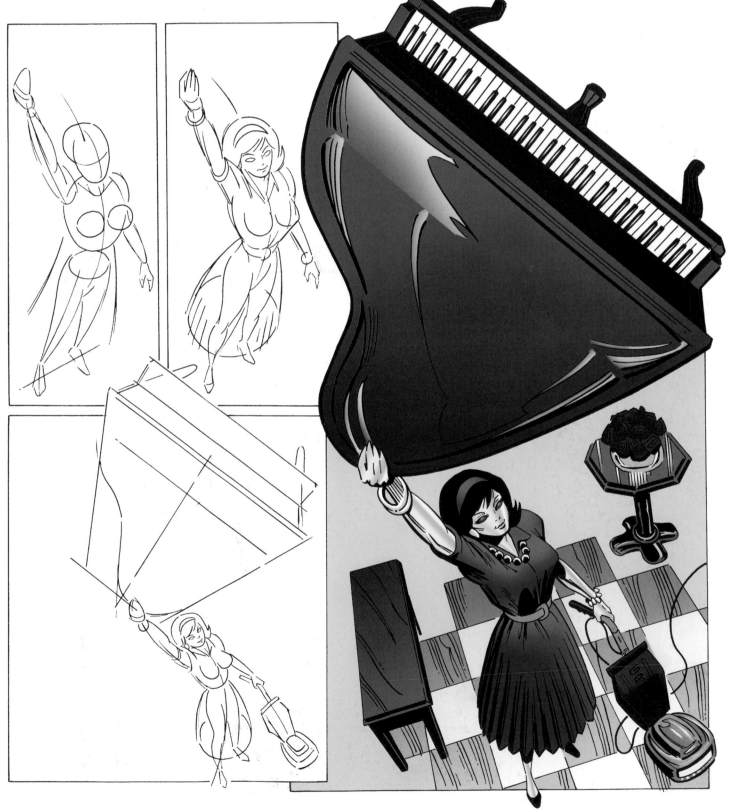

Helpful Cubes

Some robots are little drones operated by remote control. These units are great for our bank-robbing villain. A few zaps from the cubes' energy beams, and Mr. Greedy can waltz into the bank and make an unauthorized withdrawal. On robots and androids, you shouldn't overdo the gizmos and doodads. But on the remote-control drones, it's just the opposite. They should be all high-tech. They're little gadgets without much personality.

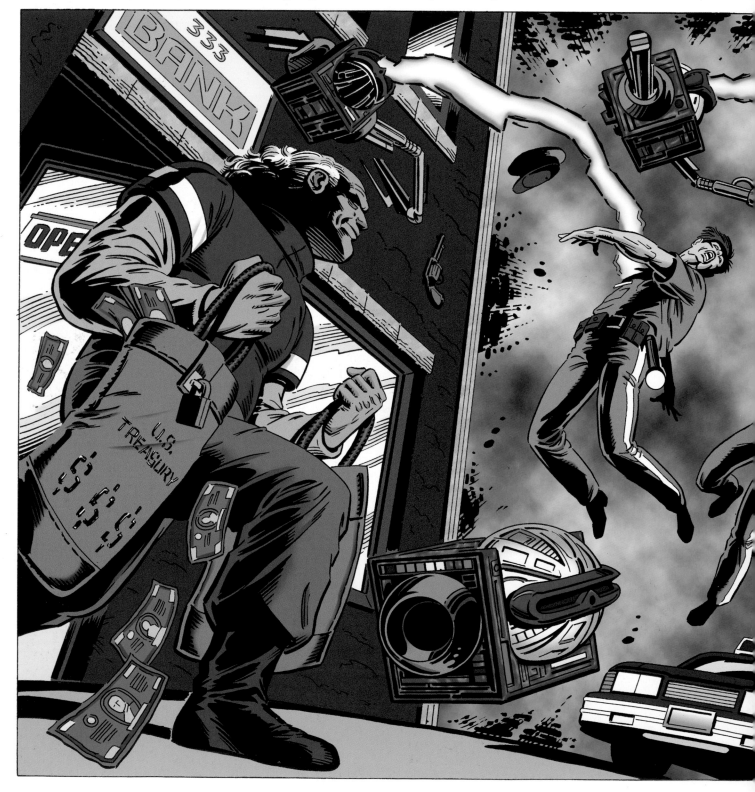

DESIGNING A RECURRING CHARACTER

As a comic book artist, you may be called upon to create a gizmo-laden character that appears throughout a story. When this happens, you'll naturally be drawing it from many different angles. Instead of just winging it, it's better to first draw a *character chart* or *model sheet* of the character from different angles. You don't want it to have three buttons in one pose and four in another. It must always look consistent.

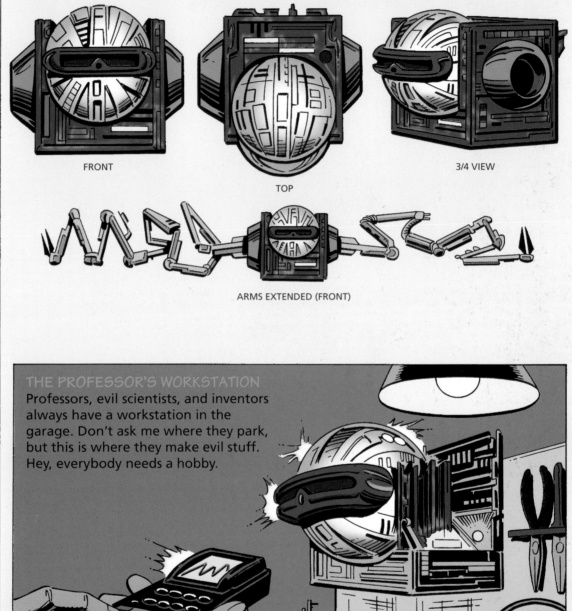

FRONT

TOP

3/4 VIEW

ARMS EXTENDED (FRONT)

THE PROFESSOR'S WORKSTATION

Professors, evil scientists, and inventors always have a workstation in the garage. Don't ask me where they park, but this is where they make evil stuff. Hey, everybody needs a hobby.

MYSTERIOUS CREATURES

If you stay up late at night and surf past some obscure cable channels, you're sure to run into documentaries that prove the creatures in this chapter exist. And, if that's not enough evidence for you, just look at the tabloids at the grocery store check-out counters. So don't tell me I'm making this stuff up.

Bigfoot

Call him bigfoot. Call him Sasquatch. Just don't call him fuzz face. Bigfoot is only found in certain locations: mountains, forests, campsites, and student film festivals. You may be tempted to draw him as a gorilla or a caveman, but he's neither. Whereas a gorilla has very short legs and extremely long arms, bigfoot's proportions more closely resemble those of a human. And while a caveman looks like a slow, brutish thug, bigfoot has the countenance of a wild animal. Every inch of his body is covered with fur.

BIGFOOT VS. MAN
Bigfoot towers over ordinary men. But it's not just his height that gives him his impressive look, it's also his girth—he's thick. Look how large that torso is—at least one and a half times the size of that of a normal man. And even though he's covered in fur, the coat is short enough to reveal the definition of his sizable muscles.

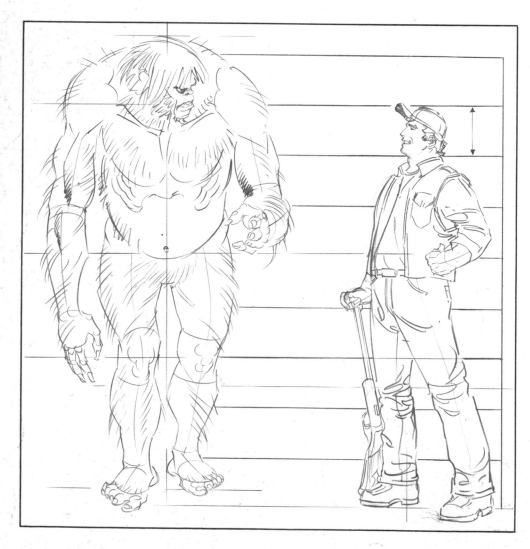

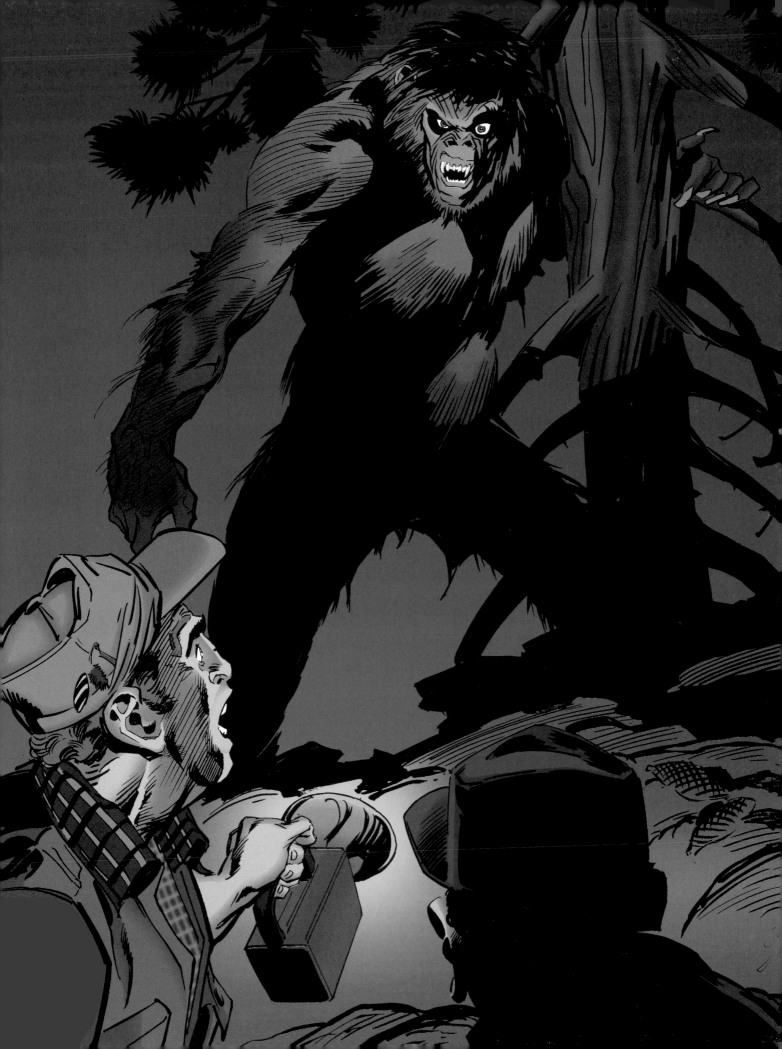

Bad Doctors: Experiments Gone Awry

Not all evil scientists are brilliant, although they all *think* they are. Some are really bad. Here, a disreputable doctor has created his very own monster. So what if the ears and eyes aren't in the right place. No one's perfect! This jumbled group of assorted parts and muscles is goofy but strong. With the shape of the head—bald on top, with a high forehead and fat jowls—this creature looks like a big baby. It will do whatever its "papa" says. Next time it needs a doctor, however, it should go out of network.

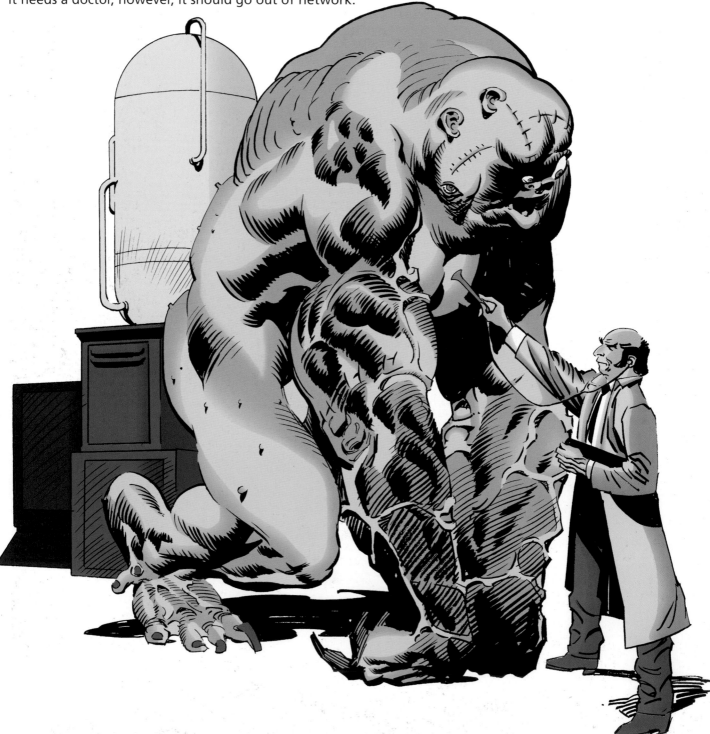

Congratulations! It's a Thing!

Ah, the joy of bringing a new life form into the world. Social satire by means of allegory is a highly effective device in horror movies and comic books. Showing aliens as human beings begs the question: Are they like us, or are *we like them?* When you show the humanity of aliens, you start to wonder: Aren't they just fighting to preserve their way of life, too? Don't shy away from the ambiguity. Stories are much more interesting if you straddle the fence rather than come down hard on one side. So, let your audience see the aliens as sentient beings, with value and a sense of self-worth. Then mow them down mercilessly.

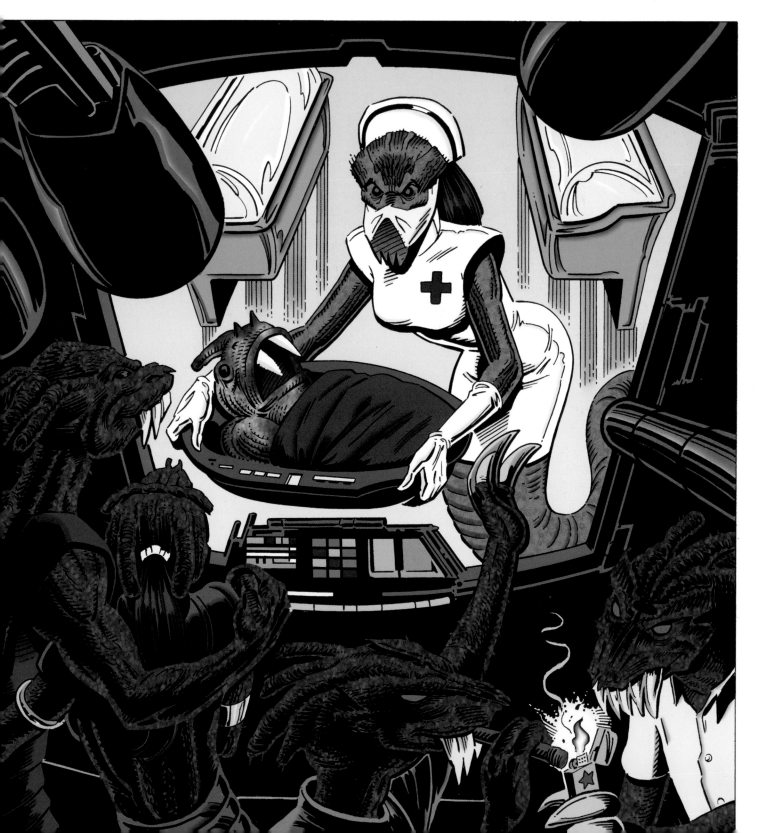

HOW THE PROS WORK

The original pencil drawing goes through several stages on its way to becoming a finished comic book illustration.

From Start to Finish

Yes, there's a method to their madness:

1. THUMBNAIL

The first thing a professional comic book artist creates is a thumbnail sketch. It's a small (like a thumbnail), quick drawing in which the artist sidesteps the details and concentrates on getting the gesture, pose, and flow of the action down.

2. REFINED THUMBNAIL

The next step is to start working in the facial features, muscles, and costume.

3. TIGHT PENCIL

Using a 2H pencil (which is a very light), the artist draws every detail, including the shadows, which are marked with little Xs indicating which sections the inker should blacken.

4. FINISHED INK

Next, the artist gives the drawing to a professional inker.

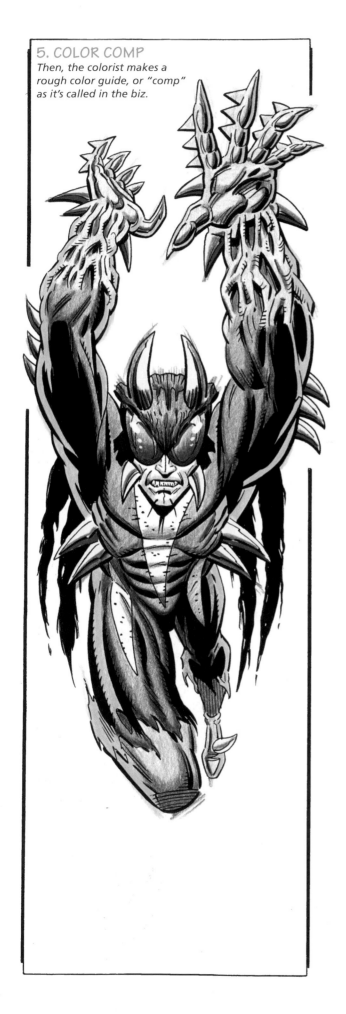

6. FINAL IMAGE

When that's approved by the editor, the colorist matches the colors from the color guide on the computer.

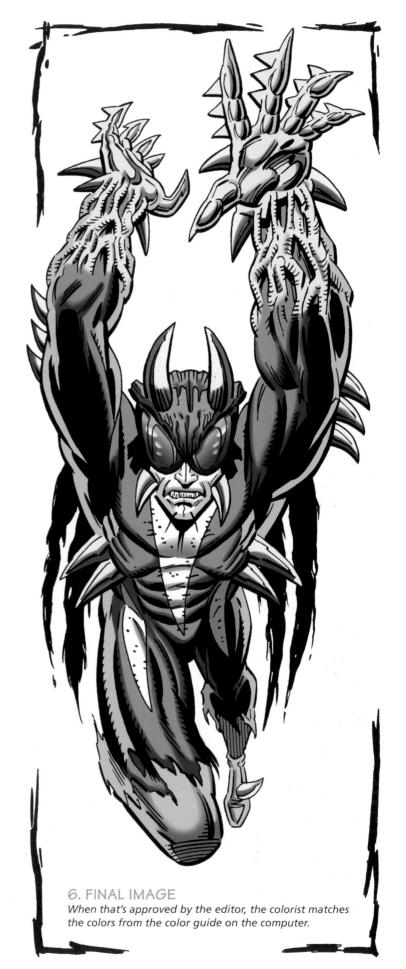

Pencil Techniques

Just because most comic book images are inked over by professional comic book inkers doesn't mean you should give up your pencil techniques! There are many independent comic book publishers, as well as publishers of graphic novels, that publish their books entirely with pencil drawings. Using a pencil is a cool look and will also improve your drawing ability, rather than relying on an inker to add all the flourishes. And it's a more direct reflection of the artist's skill, because no second person is tracing over the original drawing.

When creating a pencil drawing that's not meant to be inked, use a pencil with a softer (and therefore darker) lead, such as an HB, a B (even softer/darker), or a 2B (the softest/darkest good drawing pencil). You can get these pencils from any art supplies store. Create different shades by pressing harder or lighter on the pencil as you work. The tone chart here shows some of the possible shades attainable with a single 2B pencil. The more shades you use, the richer the image will be.

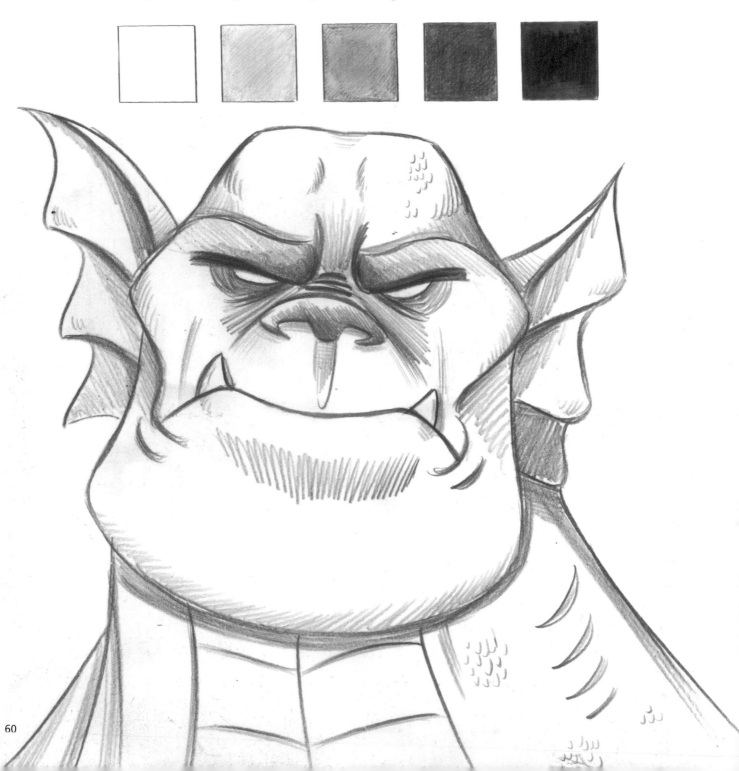

Telling a Story with Pictures

Many beginners draw a favorite character standing still or in a pose, with nothing around it. Even if the pose is a good one, it doesn't ask the viewer to suspend disbelief and step inside the scene to linger a while. Try to create some drama by telling a simple story with a *complete* illustration. For example, this winged alien has been gravely injured. One wing has been bitten off, and it has lost an arm and a lot of blood (that is, if that goop spilling from those veins qualifies as blood). The alien is up high, on a clifflike perch, surrounded by water. It probably can't fly anymore due to its mortal wounds. And just when nothing can get worse, a gigantic flying insect comes along to finish the job. Boy, Mondays are rough.

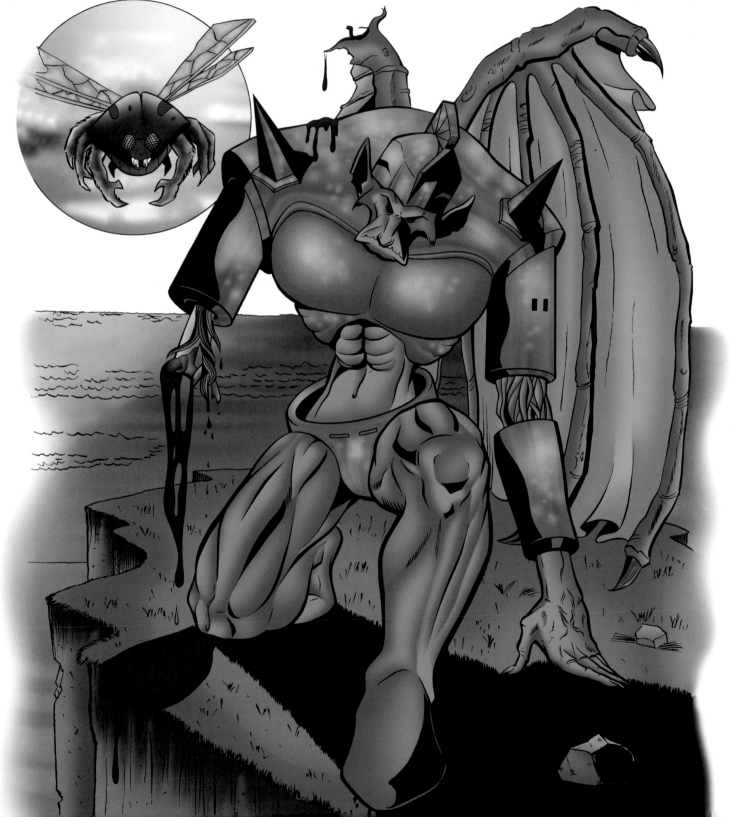

Staging
Scenes

A well-staged suspense scene (or even a comedy scene, for that matter) will have two separate things going on at the same time. And this is a good example. The first thing is that a couple has parked in a secluded spot to do the smoochy-smoochy thing. The second thing is that a creature from the swamp is hungry. The two actions allow the suspense to build, because as the man and the woman sweet-talk each other, we notice the creature rising up, and it makes us nuts! We're yelling at them in our minds, Get out of there! Unlock your lips and put the car in reverse! This approach is superior to having the couple do nothing in a scene but wait around to be frightened.

Panel Layout

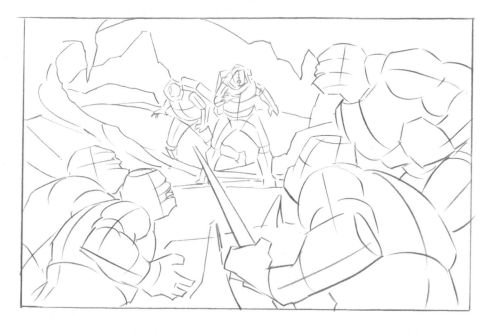

What makes this panel so appealing? Drama. You can sense a story taking shape simply because of the way the scene is laid out. The hikers are obviously in the middle of nowhere. They're probably lost, cold, and low on food. There's no civilization in sight. They've come to a cave that might provide some temporary shelter. Only the cave is already occupied—by crystalline ice creatures. Looks like the ice creatures don't take kindly to human visitors. And you can tell all this from the careful layout of this one panel! With this type of set-up, you want to turn the page to see what happens next. That's the key to good comic book storytelling!

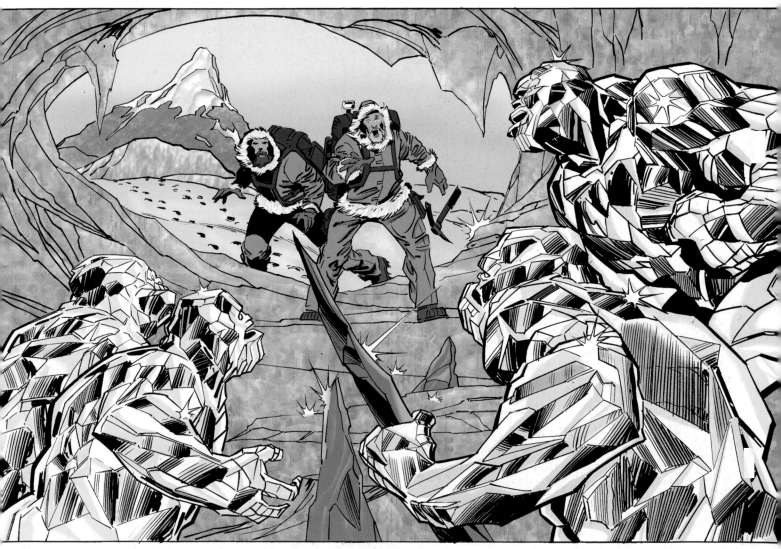

Index